Dungeon depths

Dungeon depths:
two artists explore the self-portrait

Carole Best and Anne Labovitz

First edition 2010

ISBN: 978-1-4507-2856-0

Library of Congress Cataloging-in-Publication Data available.
Library of Congress Catalog Card Number pending.

Design by: Carole Best

Edited by: Penny O'Hara

Printed by: Hefty Graphics, Inc., Minneapolis, MN, USA

This book is printed on environmentally friendly paper using vegetable-based ink.

Published by Arketis
www.arketis.com
dungeonbooks@arketis.com

Contents

About the artists vii

Introduction 1

Background 3

Diary excerpts 5

A day in the life 45

Our favourites 47

Plates 49

Acknowledgments 71

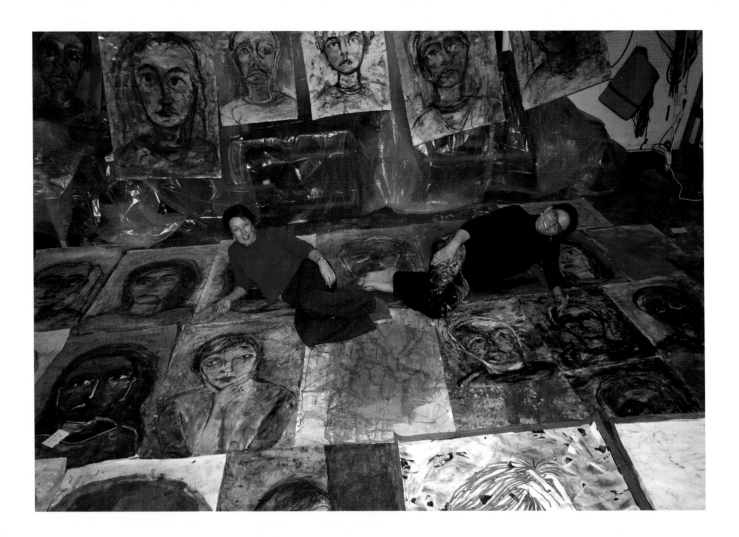

About the artists

Anne Labovitz graduated with a degree in Art and Art History from Hamline University in 1989. Anne has lived and worked in Switzerland, Germany, Spain and Italy and currently lives in Saint Paul, Minnesota. Anne is a painter and printmaker and specialises in portraiture and expressive coloured abstracts. From childhood, colour has provided deep inspiration for her and continues to powerfully inform her work. She has recently been selected as an artist for *New American paintings* magazine. Her work is held in collections in the United States and Europe. Anne has a young family and an active community life and works full-time in her studio.

Carole Best is an Australian artist who lives in the Blue Mountains in New South Wales. She has been attracted to the face as subject matter from the outset of her artistic career. Carole's preference is for techniques that allow direct, expressive and physical artmaking experiences, such as painting and drawing. Carole has been a finalist in several major portrait prizes and has work in private collections in the United States and in Australia. She currently divides her time between her work as an educator in a Sydney museum and her painting. Her favourite colour is black.

Anne and Carole have worked together since 1997. They have collaborated on three books: *Dungeon dwellings (Champagne book), Dungeon dwellings #2,* and *A dozen dungeon days*. The first exhibition of their work, *Mostra*, was held in 1997 in Barga, Italy. Since then they have had two more exhibitions together: *Dungeon duo* in 2000 and, in 2001, *Brown is black*.

Introduction

We first met in Italy during the summer of 1997. We were enrolled at Studio Camnitzer, a residential art school specialising in printmaking. The school, ably lead and inspired by Luis Camnitzer, boasted a wonderful mix of nationalities and artistic pursuits. As it transpired, both of us were too messy for the etching studio and were relegated to the *other* studio space: an old wine cellar affectionately known as the 'Dungeon'. In that dungeon we became best friends.

Since then, our friendship has been fortified by our biennial sojourns when we meet and work for a month together. We have met in several locations around the world, working in a series of different underground studios—each of which we've been quick to nickname the 'Dungeon'.

Our seventh and most recent meeting took place in 2010, in the well-below-freezing temperatures of a winter in Minnesota. The weather, the underground studio, and our chosen subject matter—the self-portrait—provided the perfect opportunity for introspection. During our weeks together we kept a daily diary, and some of our conversations and thoughts are recorded in the extracts that follow: they focus on the highs and lows of exploring ourselves up close and personal.

This book is for anyone who is fascinated by the evolution of a painting from first mark to last dab of paint. It's for those working creatively, as well as those wishing they were, and those thinking they one day might. It describes our artmaking process from concept to clean-up. Writers, musicians, and other artists will recognise themselves in our process: it's one where the *making* of the art, the *doing* of it, takes precedence over all else. It provides a chance to experiment, an opportunity to put into action all the ideas and thoughts which have collected in the crevices of our brains, hiding there, poised waiting for their moment. It's a cathartic, intense, sometimes emotional time—a mass birthing of our creative product.

This is also a book for our fellow painters, who may at this moment be peering into a mirror and sketching down the image: searching for what it may reveal and trying to harness it to echo the aches and pains and joys of being alive.

Background

Over the course of 2009, Anne had been working intensively to develop and perfect an acrylic layering system that could deliver intensity and depth of colour to her abstract work. She wanted to simulate a technique she had used while working with artist and friend Harold Adams, which had employed oil paint and polyurethane to build a multi-layered, high-gloss finish. This method was toxic and unsuitable for use in her studio. Finding a similar, non-toxic and quick-drying technique became an imperative.

Anne spent long hours experimenting with different types of GOLDEN brand acrylic polymer emulsions to which she added various colour tints. She mixed with zealous alchemy to achieve a high-gloss, smooth and self-levelling emulsion, one that would accept tinting with a minimum of colour change or opacity development.

Anne calls her special mix of polymer emulsion 'gloop'. To 'gloop' is to spread very thin layers of this mix across the surface of the work with a huge spatula. Some of Anne's works have up to seventy layers of gloop. Each layer is tinted separately and isolates the previous layer and its markings from the next. Gloop is, in Anne's eyes, pure magic!

For our month together Anne had anticipated continuing to build a body of work for a show later in the year. She decided to try to incorporate the process of glooping with more traditional drawing and painting techniques on the theme of self-portraits.

Before arriving in the frozen north I'd had numerous conversations with Anne about gloop and its special qualities. I came prepared to try to develop expertise in Anne's acrylic layering techniques while exploring the self-portrait. My own interest in self-portraiture underpins my interest in portraiture in general and my proclivity towards it is bitter-sweet—part longing to see who I am and part longing to create and invent myself anew. As I had recently given a talk on one of my self-portraits (selected for the Portia Geach Memorial Award in Australia), my appetite for the self-portrait had once again been whetted and I had determined to spend the whole month with Anne exploring the subject.

This chapter of our story begins as we journey from Anne's home in Saint Paul to Duluth for a week's painting in the underground studio—yet another Dungeon—of the house where she grew up.

Carole Best

Diary excerpts

Anne: We are in the car driving past Pine City which is ninety-five miles from Duluth. It's 8 pm and my daughter is in the back watching a DVD. Carole is beside me typing this into the laptop as we drive. We left the boys at home; they were all excited we were leaving!

I feel like I've really been concentrating and working since Carole arrived last week. At the same time, I've been feeling unsure about how to combine the media of the portrait with the layering of the tinted polymer emulsion. I have twelve 24 × 30 inch sheets of paper on which I had previously laid down several layers of colour. Today I outlined a space on each of these within which I intend to draw the portraits. But I am very unclear what to do next: do I add more to the colour layers or begin to work into the face with drawing?

This is all very different to how I have been working over the last eighteen months. My work over that period utilised tinted acrylic washes where each layer is isolated from the last by the plastic film developed as the paint dries. As the layers build up it creates amazing depth and luminosity. It's quite a different way of working to drawing with line.

This process of layering transparent fields of colour was directly inspired by working with Harold Adams, who I painted with every day for three months last year. Harold uses polyurethane and shavings of paint to create layers of powerful visual impact. His infectious energy thrust me forward while also making me focus much more acutely on technical process. During this time, I also worked feverishly in my own studio to expand my vocabulary in acrylics in order to simulate Harold's oil-based system. That's how I came up with the technique of layering tinted acrylic washes.

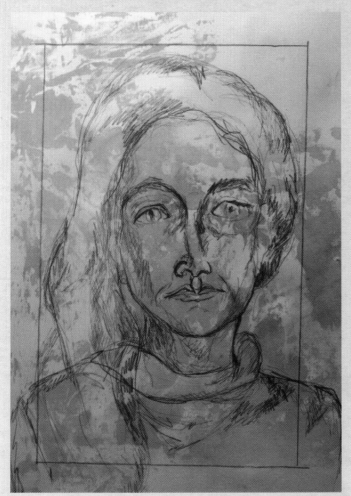

Anne: It is quite momentous for me to come to my childhood home for this 'art camp'! *Strange and oddly evocative.* The idea of self-portraiture is interesting as I am in my family home, with my young daughter, and next week I will turn forty-five. Intriguing for me now is to ponder how I look and how that impacts on my self-portraits. I have never cared about that before.

Despite having delineated the shapes for the portraits on the prepared coloured backgrounds, today I decided to work on building up fields of colour on fresh white paper. I used medium body and normal paint and water directly onto the paper. This gave me a watercolour effect and kept the paper porous, which means it reacts differently to each layer.

I've been thinking about the aesthetics of melding colour fields, which are totally abstract, with the self-portrait. My large portraits are usually really intense—dynamic and emotional—and I'm not sure how that will work with acrylic colour fields, which are more decorative in effect. I'm thinking I'll need heaps and heaps of layers so that the drawn image disperses and almost becomes a reflection, or a ghost ... but I am in there somewhere too.

7

Carole: Today I woke up and had to come to terms with Lake Superior: a lake that looks like a sea! I have never seen such a large body of water that *isn't* the sea: it's fresh water but it behaves like an ocean. Anne says that when it's rough the waves splash right up onto the top-storey windows!

After several major challenges with cutting paper to a size that can be shipped back to Australia and framed appropriately, I began with a set of five portraits. I stained the paper with flat colour and then waited till dry and coated with gesso using the 'big mama' spatula.

I purposely left gaps in the gesso so the colours would show through. Anne's daughter suggested I do one with turquoise which at first I resisted strongly, but it's turned out really well as I added yellow ochre, aquamarine and red. I am now thinking that I will put the portrait over that and then sand back to reveal the colours below.

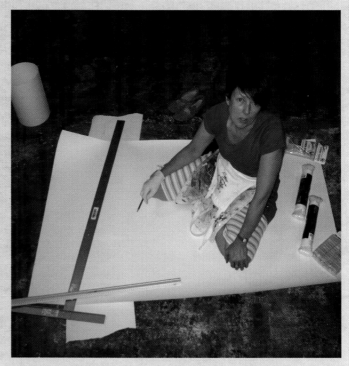

Anne: Good night last night, mostly working on ten portraits—all based on the same photo—on

30 x 44 inch Rives BFK paper. *Primarily in earth tones.* I'm working on one after the other, creating very watery surfaces over which I rub another piece of paper. I have been using this to create a transfer print on top of the ones already started.

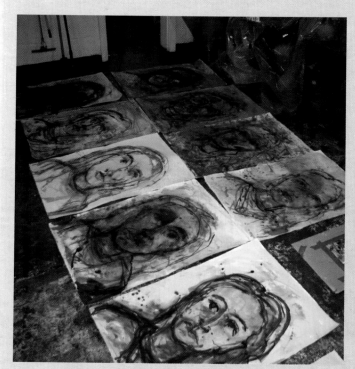

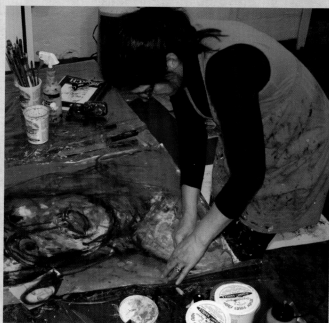

Carole: This morning I was presented with last night's ugly images. It's difficult when the work you envisage in your mind's eye falls short of

the reality. *The marks are never as subtle or sophisticated or as poignant as I imagine them.* I am never sure if this is to do with a skill set that I don't have, or if that's just how it is for every artist.

The larger pieces that I had layered up with several colours, a rough portrait and coats of gesso—in the hope that when I sanded them it would reveal parts of the drawn images and patches of colour— proved to be a lot of effort for little benefit. The sanding proved ineffective other than to tear the paper and mark the images.

Several other portraits are beginning to take shape. At the moment I can work with abandon as I don't like anything I have created so far. Once I do begin to sense an image within, things will begin to get much harder, as I will be forced to make decisions based on the aesthetics of the piece.

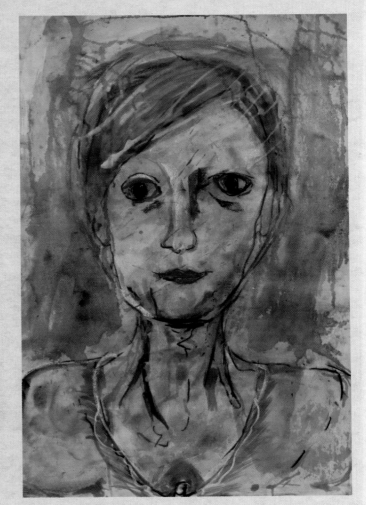

Anne: I lost the faith a little bit last night. So I decided to 'rely on the process', treating every piece I had started systematically, one by one. Just drawing into them over and over, adding thin layers of watery wash and pastel. I wasn't sure I was getting anywhere, but I let go of the expectations and just continued. It's always a fine line between keeping an idea and letting that same idea go, allowing the work you have made influence and inform the next mark.

On leaving Saint Paul we purposely limited what we brought to Duluth to those materials which could be manipulated over a wide range of uses. For example, any of the acrylics can be made into very thin washes or thin paint, or something in-between. They can also be mixed with polymer medium to form gloop.

Because the supplies at hand dictate what materials I can use, I'm forced to make different choices to those I'd make if I was in my studio. For instance, the airbrush paints—which I normally rely on a lot—aren't here, so I find myself using pastel and charcoal. The limitations create different work and push you to find new solutions.

To the Dungeon we will go!

11

Carole: Last night we worked until after 2.30 am and then I couldn't get to sleep, so **I woke feeling crap and have struggled through the day.** There is no natural light here in the studio and my mind is going crazy not knowing if it's morning or night.

Anyway, I made the commitment to myself to follow Anne's lead and build an image just by continually working on it. Layer after layer to lose, and then find, the form within. It's hard, and I can feel myself limited by all sorts of things: lack of containers, few brush choices, coloured pastels that don't suit. Nothing I have made is good, nor do I like anything, but I am waiting to see what eventuates.

My intention here is to paint portraits of me specifically, rather than the more generic 'heads' of previous work. When I see Anne draw herself, it occurs to me that she has a lot more to draw: she has heaps of hair and distinct lips and deep-set eyes. Whereas I have the feeblest of features and this impacts on the drawing: there just isn't that much to see! So I have chosen poses which are descriptive of me, like my hands in my hair. When I look at these drawings I am constantly reminded that I am getting older and progressively less attractive and less remarkable.

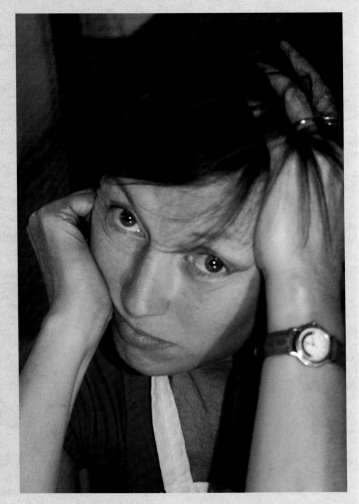

12

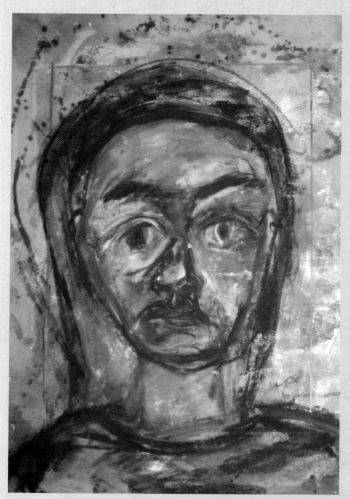

Anne: I feel like `I've made major progress`, with a significant breakthrough on one of my pieces.

I began the work by using multiple washes on Rives BFK paper. I applied thin films of colour glaze, combining the glazing mediums with drips and palette scrapes of airbrush paint. I then delineated a frame roughly three inches inside the page with the intention of placing the portrait within it. I wanted to draw with crayon, but the surface was so slick the crayon skidded across, so I began painting.

The work developed using the additional technique of transferring very watery images from a similar-sized canvas, by reversing the watery portrait onto the paper and simply patting and lightly rubbing.

As the form developed through working with charcoal and ink and watered-down paint, I started to use Stabilo Tone pencils and made really powerful drawing marks on top of the painting.

The juxtaposition of the shiny iridescent depths with the energetic line quality and dull painted washes creates the synergy I was hoping for. I have achieved my goal: the work maintains the integrity of the glossy abstract surface, but the portrait also gives it an intensity of line and feeling.

13

Carole: It rained today and I kept looking out to see if it was raining ice as was forecast.

I have never seen it rain ice.

Studio time was very productive. Although I am working slowly I have a few pieces which address my aims. I have three good drawings of myself in poses using my hands on large 120 × 100 centimetre Lenox paper.

After my failed attempts to sand them to achieve showthrough—and thereby develop another image—I decided to work directly over the patchy gesso, and have achieved something I had not predicted. The drawings are simple sketches, but they work! Partly because of the coloured gaps in the gesso and partly because the compositions are squashed down in some way—either to the edge or to the side. They are monochromatic which pleases me. Not being a colour queen like Anne!

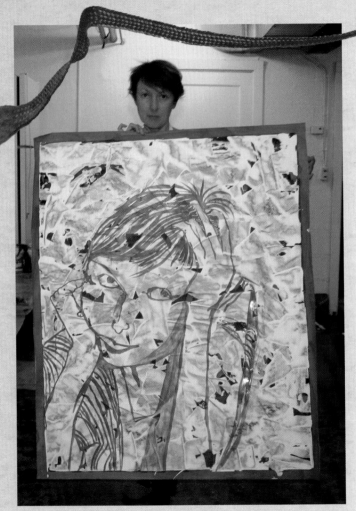

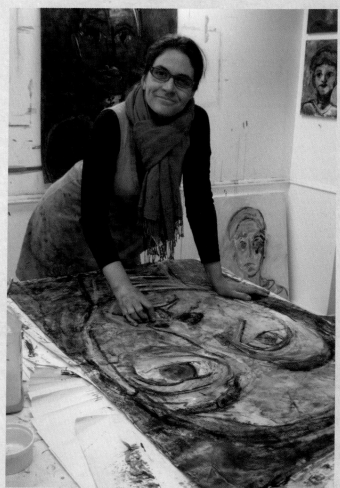

Anne: Well, we have returned to Saint Paul. It's nice to be back in the home studio after our sojourn to Duluth. It's also nice to see the work hanging vertically as we worked horizontally there and it was hard to see our progress. We were welcomed home by Bill's music as he played tonight and

`it filled me with warmth.`

I still feel really pleased with that one piece I finished in Duluth. I've cut up more of the same size and drawn in the graphite frame.

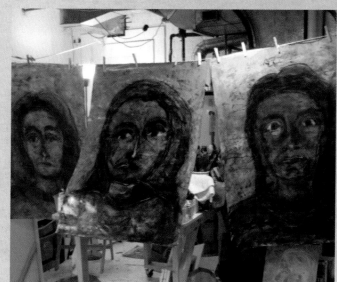

15

Carole: Today we went skiing and after that I worked till midnight in the studio and finished the first piece for the trip. It's a large red ink self-portrait against a thick black textured background. The figure is all white with red line and I love it. Anne's daughter said, '*It doesn't look like you because there aren't any lines on your face*', at which I half laughed and half cringed, but regardless of the absent ageing factor it feels like me to me!

Tonight I printed more photos of myself. I am going to draw myself in new poses, lying on my arms lengthways on the paper. This type of fine, observed drawing doesn't come as naturally to me as a looser, more expressive approach, but I want to be able to place the face or figure in a way that utilises the negative space more powerfully.

I also painted up another of the sketches I had done in grey chalk while in Duluth. I added a big indigo shadow and tried hard to use somewhat realistic tones for the face and hands. I have been reading about and looking at Alice Neel's portraits and feel inspired by her use of the shadow as an active part of the portrait and the way she outlines her figures. For the first coat it looks okay, but still a long way to go.

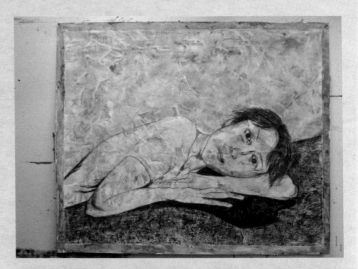

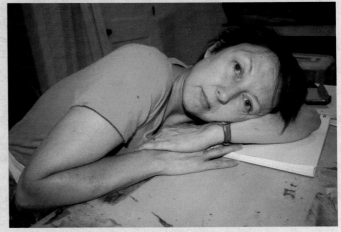

16

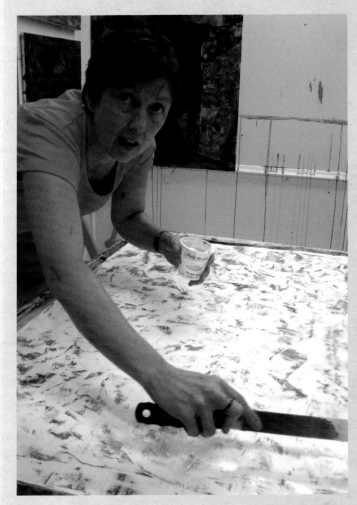

Carole: I did some good work today and managed to plan my activities to suit the day. Was up till 3.30 am cutting and gessoeing new paper. It's a pain-in-the-butt job at any time and really pushed me to the limit last night.

As soon as I came down this morning, I laid in single colours. Once they were dry I applied more gesso using the scraper to achieve a textured and open surface for drawing. I can see Anne's influence on me in the preparation of these grounds—they almost mimic her layered glossy surfaces, except for the lack of depth and detail. Who would have thought that I would ever have wanted to draw on anything other than a pristine white sheet of paper with a black crayon? Weird things happen in a dungeon!

17

Anne: Today Carole encouraged me to put the ten new abstract paintings which I started yesterday in the 'pause' pile, and to go back instead to the self-portraits.

My reluctance to do this stems from a passion for starting new work, but also from the fact that I find it difficult to consider the self-portrait as a valid art form for me. It's uncomfortable to be concentrating on myself visually and somehow feels a bit self-indulgent. But it's strange—I am carving a woodblock at the moment which is *also* a self-portrait, and that feels perfectly acceptable and lovely.

Now, I want to talk about pencil. Last night I drew my head on a 12 × 16 inch woodblock and I thought, *Oh, that's nice drawing.* I reflected that the quality of the drawing was strong and intimate and from that moment on I formed an unbreakable allegiance with the pencil. I noticed that many of my abstract works have pencil—actually graphite— lines. The graphite seems to maintain its integrity and line quality even underneath twenty or thirty layers of gloop. So today, with much dialogue about the endearing qualities of pencil, I drew three self-portraits on top of lightly colour-washed Rives.

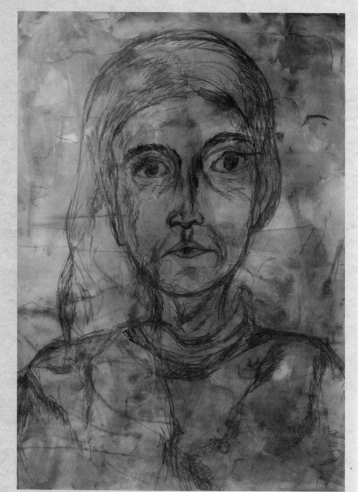

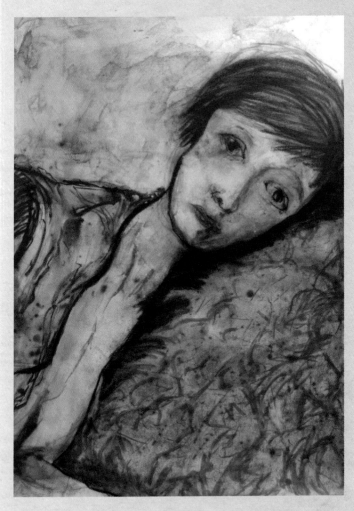

Carole: This morning was a bit of a disaster. We began the day all breakfasted and `revved up with caffeine` in order to spray-fix our pastel drawings. This is not a fun job on any day. I hauled the large drawings up the stairs and outside onto the porch where I sprayed and left them in the sun. When I returned I found they had *not* dried at all and the fixative was pooling on the work! (Silly me, what was I thinking when the outside temperature was minus six degrees Celsius?) More heat was desperately needed, so I hauled them back down to the Dungeon. That was a big mistake! The fumes were horrific and both Anne and I were forced to open all the windows and vacate the space urgently. After an hour I returned, but by that time I had lost my Dungeonmate to her bed. So the first part of our day was dashed.

Last night I discovered graphite sticks. It's as good as it gets. Thick blocks of 9B and a putty rubber led me along a path I have never been down before. Rubbing as much graphite as I could onto a drawing I had started in Duluth brought me a silvery, soft image which I then glooped with blue.

Going well; discovering new things, pushing images where they have never been before and beginning to develop my own special relationship with gloop.

Anne: I've been doing portraits and self-portraits for twenty-five years now and only today have I finally come to regard the self-portrait as a legitimate genre in its own right.

My self-portraits are never pretty in the classic portrait sense. They are very expressive and really different to my commission portrait work, which is typically softer and more accessible somehow. The self-portraits are heavier, more intense—larger in every way—and demand a response from the viewer. Juxtaposed against their size is the level of intimate emotion.

The work I have been doing over the past few weeks, although coloured, has a strong relationship to the large black heads Carole and I did five years ago. The current work, like those heads, is wrought intuitively—with the hands and by the

heart—and as a result also has a similar **level of confrontation.** It's funny, because although the black heads were well-received when initially exhibited, over the years I have had a couple of restrictive comments about exhibiting them in commercial venues. This is effecting my treatment of the current pieces and doesn't serve the work or me as it inhibits my passion in exploring the self-portrait and the newer coloured medium to the fullest extent.

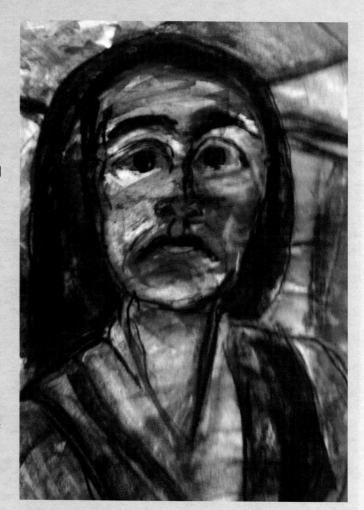

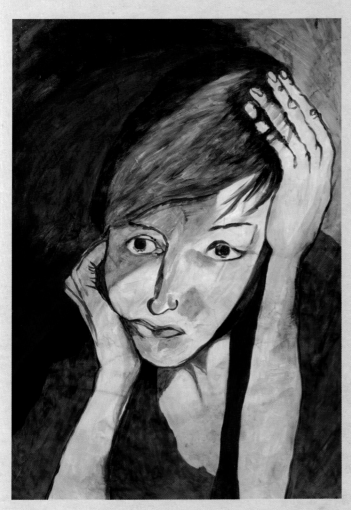

Carole: I am struggling with the graphite piece I was working on yesterday. I have called it the 'hyena piece', as that's what Anne's daughter calls it. It's dark and silvery, and it's got definite potential. But I started glooping it and have had a number of setbacks. There are deep puddles forming, and the underdrawing has turned violet under the gloop. I tried to counteract it with an application of yellow, but it falls very short of the indigo mood I had envisaged.

Self-portrait as Nancy Drew—the piece that I began painting up on Wednesday—is almost finished, as a result of studying the blue outlines Alice Neel used in many of her portraits.
`A very successful exercise in the value of ominously placed shadows`. I do feel this coming on as a bit of a theme in my work.

The drawing of me lying on my hands is also progressing. I have begun a very satisfying disintegration process using dripping and layers of yellow and ochre which I want to press down on the figure, squashing her even further into her puddle of shadow on the table.

Right now I am sitting in the Dungeon in a wonderful draft of fresh air, drinking champagne and feeling perfectly content.

Anne: A really cathartic moment last night: the girl in my work cried. *I let her cry.*

I sprayed water and made the heavy pastel run. I wiped her eyes and let the residual tear stains remain.

I think the process was really important for her and for me. The work moved through intense sadness and today I approached it with continued commitment and passion.

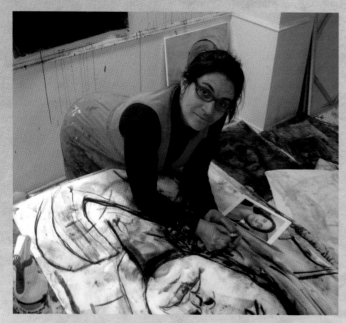

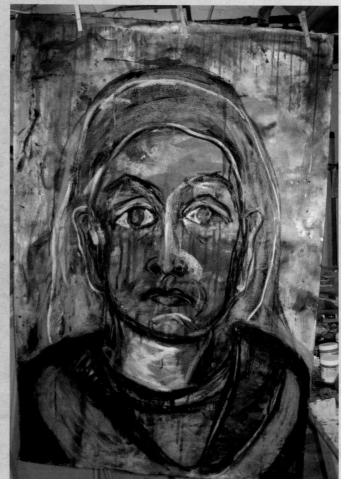

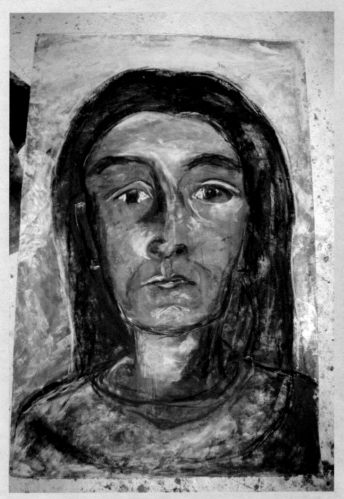

Anne: `Big blue heads.` The development of the form of these heads seems more structural and firm, potentially less mask-like. Two of these blue heads I began on top of landscape washes in Duluth, and one of them has the horizon line right down the middle of her face, which is interesting.

It harkens back to work I have done before where I've divided the face in half and treated each side differently, so I am intrigued to see what eventuates.

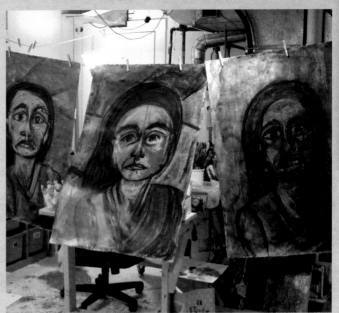

Carole: Not such a good day today, mainly because **I am feeling unable.** I can't explain it any other way, but the feeling is part helplessness, part frustration and part sadness.

It's a feeling that comes when I can't realise an image because I feel like I don't have the skill set required. It makes me timid and reticent.

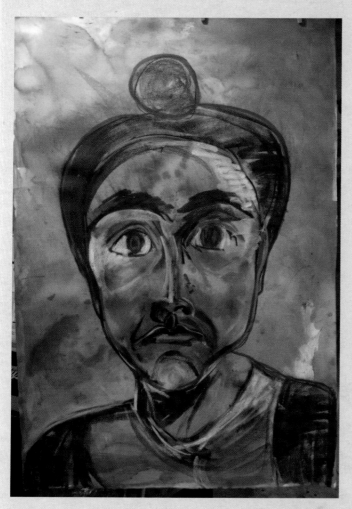

Anne: Okay, it's my birthday: forty-five today.

I've been reflecting on the fact that *every single one of my portraits makes eye contact.* Always.

I don't even want to consider doing a portrait that's a 'side mouth'.

As I think about Carole's portraits, it strikes me that even though she desires to make them decrepit and confrontational for the viewer, somehow she also maintains that her works must be palatable. She has chosen to paint a series of portraits of herself in half-profile, with eyes casting off and a longing look focused to the distance. Thus, even the most disturbed image is available to view without confronting the essence of the person. That's really different to looking at someone smack dab in the face. When you do that, you are interacting with their essence. And that calls for a different relationship between the viewer and the work.

I am only interested in the absolute moment of truth—now. Intellectually, I do find other poses evocative, but in the end I need the head and shoulders facing forward and the eyes looking at me.

Carole: As a maker of 'side mouth' portraits I feel obliged to explain my position!

Some days ago, Anne and I began debating this whole issue of front-facing versus 'side mouth' portraits, and by extension, aesthetics versus emotional expression. It all began when I produced a self-portrait—posed directly facing the viewer—

which scared me. *It was so fierce, and so 'me'*. Anne's view was that it was great to have her so fierce and so what if no-one wanted to look at her? Whereas I wanted to modify her—to shrink her head a bit, to manage her hair better, to tone down the background; to make her more palatable in exactly the ways we moderate ourselves.

I felt she was ugly and way too huge for the space!

I suppose it comes down to a fundamental difference in the way Anne and I approach our work. For Anne, it's about the *expression*. For me, on the other hand, it's about communicating something to the viewer—in that way I consider myself a visual communicator. I have been the maker of several abhorrent portraits: now, what I mean by that is that not only were they very emotionally powerful, they were unpleasant to

look at. If no-one looks at your art because it's ugly, then you have no audience. And as a visual communicator that doesn't serve me.

Related to this approach is the fact that I also often have direct 'intentions' for my pieces. I usually express these to Anne by saying things like, 'I want her to be huddled in the corner of the work', or, 'I want her to look tired and vulnerable', or, 'I want to utilise the negative space to make her look small.' I choose the pose and photo that I think will best allow me to realise these intentions and work from there.

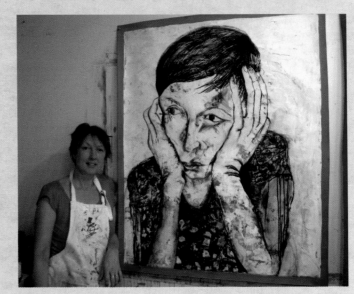

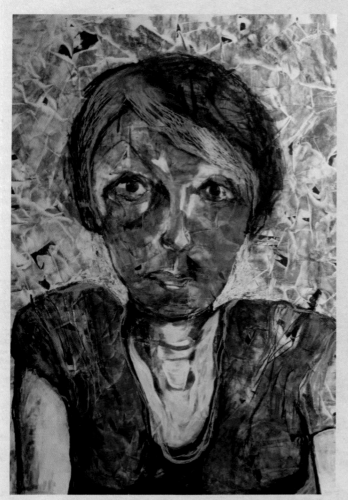

The intentions for the piece usually evolve as the work develops. I make decisions about its direction partly because I *feel* it in the piece as it takes shape. But I also make these decisions because I want to exert control or mastery over the piece, in order to communicate my idea. So when the 'scary me' portrait suddenly appeared, as if out of nowhere, it was a shock. I felt completely stumped as to how to deal with her. It was a revelation about myself as much as it was about the art.

PS: I have shrunk her head and dealt with her hair and toned down the background and hopefully you the viewer will want to look at her. And maybe, just maybe, if I have done my job as an artist, you will also see deep into her and know **she is holding herself together to face the world.**

Anne: The other night when I let my portraits cry, *I began talking to them* in a nurturing, though sometimes authoritative, manner. Since then, I've noticed that both Carole and I talk to our portraits. Because they are self-portraits it is like talking to yourself, or at least part of yourself, and helping that part of yourself come to terms with being exposed.

I think this is significant. Talking to the portrait helps the artist express intimate or shocking or difficult emotions. But it's also a way of facilitating the character development of the portrait: through talking to it, we give the piece a personality.

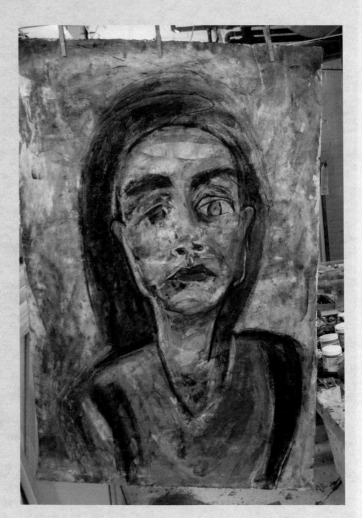

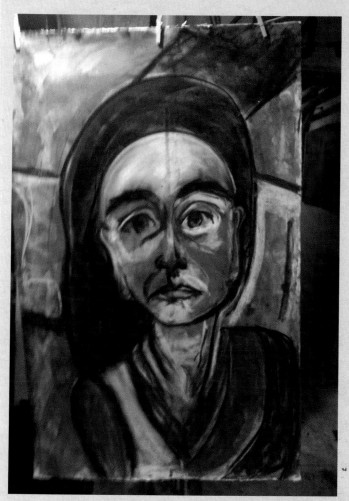

Anne: I worked on the blue heads today and felt really good. I tried to pull my absolute favourite one away from the darkness. She got so dark when I tried to gloop her, I nearly lost her, and had to trowel on some light-coloured paint and try to work over it. I had to let it dry and then it was a fair image to work with. I started with charcoal and pastel and it is developing nicely.

After I made dinner Carole and I went to Wet Paint to get more art supplies on the way to my birthday celebration. My girlfriends gave me a big party which left me with a lovely warm feeling. Printed on the napkins ('serviettes', as Carole calls them) was, 'Anne is 45. Happy Birthday.' It is worth mentioning that in the last three weeks it is the only night we have gone out.

Carole: We've been to a party! It was a great night with Mexican food and lots of Anne's friends. My mind is fuzzy with margaritas of which I drank at least six glasses. Probably way too many!

We are in the Dungeon *not doing very much*. The night is a blur, but a good blur.

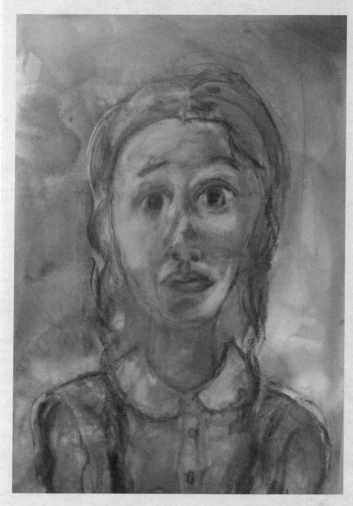

Only one week left and still so much to do!

Anne: For the last four days I've had three large canvasses out to start portraits of the children. Tonight I've just begun one using pencil and pastel. I am so happy as my eldest son feels well again after three weeks of strep infection and CMV. I had him here in the studio yesterday and I noticed how much he has changed since I last did his portrait.

Today I worked on a piece for the school's fundraising auction. It's on wood: gloop on gloop with a wet line of airbrush colour. I remembered how much I enjoyed that way of working—just using gloop in luscious layers.

Still feeling happy and loved from the wonderful party my friends gave me last night.

Carole: I am stuck. All five pieces I am working on seem to have ground to a halt. True, I did sport a significant hangover for the best part of the day, but that's not the reason. I have temporarily lost the motivation for the self-portrait, and that is manifesting itself in a number of ways: not wanting to take new photos of myself on which to base new pieces, an inability to finish the works I've started, and a nagging obligation to the papers I have already prepared. Maybe it's because all the finished portraits are stacked away and I can't see where I've come from. Maybe it's also that I only have one week left before I go home, and a feeling of hopelessness has come over me.

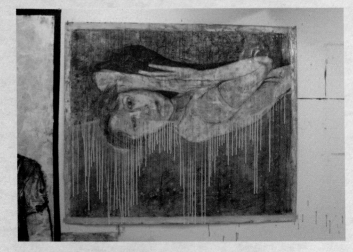

The piece from several days ago—the one that sparked the long debate about aesthetics and emotional expression—is well and truly in the toilet. The neck is all wrong and I am fiddling around the edges of her in an attempt to salvage whatever was nice about her. (I've forgotten what it was.)

I am ready to throw in the towel, but Anne says I have to try to fix the neck.

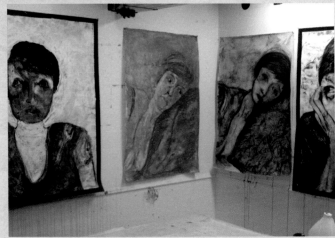

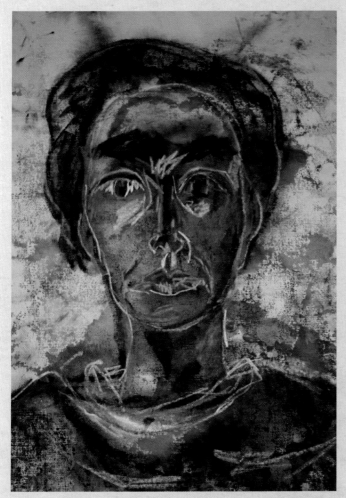

Anne: Tonight we went to the Weisman Art Museum in Minneapolis for the opening of *Common sense: art and the quotidian.* As a Board Member I was hosting the artists whose work is in the show. I think it was really important for Carole and I to have to answer the question, 'What are you working on?' when asked by other artists. To verbalise that we are focusing on self-portraiture for our month together was quite clarifying for me.

Talking about our work to others also made me ponder the question: what is a 'painting'? It struck me that all of our works so far are essentially *drawings.* There may be fluidity of mark and tone, but I realise I have only used a paintbrush once.

The distinction is important, because I believe I need the immediacy of drawing, with its intensity and surety of mark, to ensure **absolute direct emotional contact** with the piece. Spraying water and alcohol to disperse the pigment transforms the initial drawing into something resembling a painting. I build the image further by forcing the pigments around with a trowel.

In the next phase I solidify the image through applying the polymer mediums. This further transforms the drawing into a painting, and hopefully it can be sealed, framed and displayed without glass: `naked and exposed to the viewer.`

In some ways, this new way of working addresses all the reasons I stopped doing pastel and charcoal drawings. I had always loved working with pastels but I gradually drifted into oil as my preferred medium, out of frustration with the instability of the method. I remember how big the pinholes got when the work was pinned to the wall, how the piece would gyrate all over the place as you worked on it, and no matter what you did to seal the piece and frame it, over time the pastel would fall as dust to the bottom of the mat. I love and am passionate about this new method and greatly relieved that I can now create something that is stable.

Time is ticking away. only 6 days left...

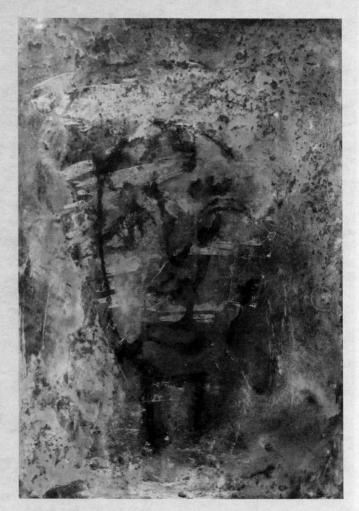

34

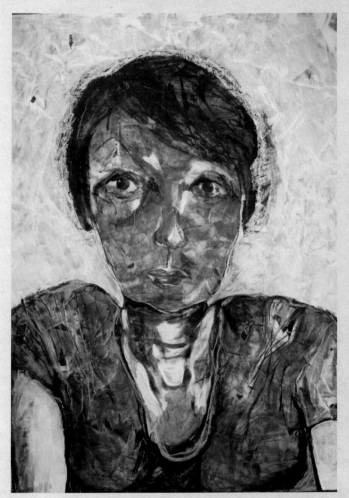

Carole: I have been *haunted by the face* I am trying to fix. She comes to me in my dreams and no matter what I do to her I cannot make her 'right'.

I realised that she is, in fact, the closest thing to a self-portrait I have ever done. She is so see-through, so vulnerable in her ugliness and her fragility that it physically pains me to gaze upon her. I have decided to leave her alone in her fragile state as a reminder of how close I came to painting myself.

After Anne's big rave about drawings versus paintings I want to add a couple of things. First, I came to the realisation that my pieces are in fact drawings, and this does not entirely please me. This new process of working with gloop has shown me that the choice of black for my first mark is often a poor one. Too early in the process I am forced into a position of refinement, of pulling back, adding whites to define and refine the image when it is still single-faceted. Anne's approach allows marks to be added all the way through the process, and although she does use black it's often later in the construction of the image.

My black default means that my works remain as drawings and have a single dimension about them that is less appealing to me. So today I have started five more full-frontals and used only wash and coloured pastels. I had to wet the paper so it would really absorb the paint; it got so limp it stuck to the table. I used the trowel to spread the pigments and fill in any white or blank patches.

We will see.

I am going for a walk now as the new pieces are all still wet, but also the light will be fading soon. For the past few days when I've walked past a snow bank I have stopped and drawn a self-portrait in the snow. Each time I go out I try to visit them.

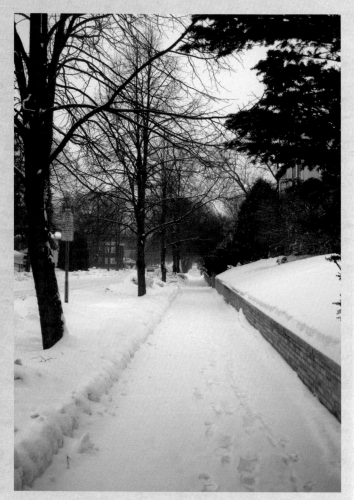

Anne: The intriguing conversation we have been having about why artists do self-portraits continued well into the night and kept us focused.

For me, the self-portrait is a way of exploring human frailty and emotion in all its forms: our vulnerability, pride and pretence. When I approach my own face in my work I am less concerned with portraying my physical likeness than with examining my inner self; the self-portrait provides me with an opportunity to delve deep into my internal psyche and feelings.

I wouldn't normally talk about these feelings—except perhaps in the Dungeon, and only after many hours of discussion about the works and what they evoke in us. It's the total abandonment that I allow myself when creating art that enables me to communicate these feelings though my work.

I can't do it any other way. The marks I make in doing a self-portrait are really raw and unrefined; they are very different to those I use when painting the children or doing other commission work. I am also called to use black more often and to use it with forcefulness.

While Carole is out walking I will carefully draw out a self-portrait onto wood, where black and solidity of mark are not just welcome, but demanded.

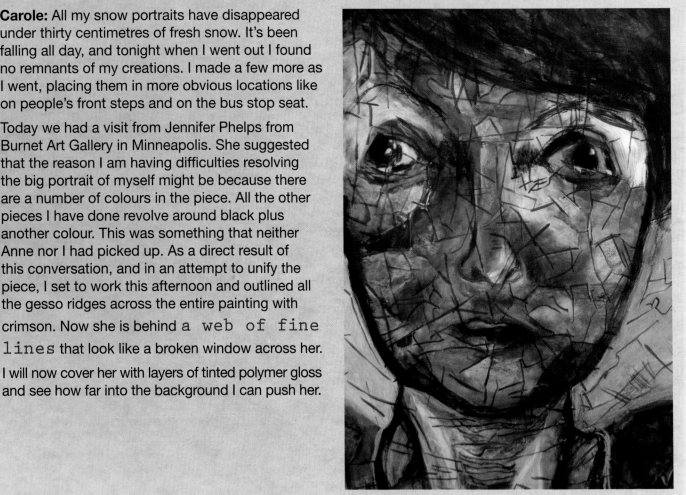

Carole: All my snow portraits have disappeared under thirty centimetres of fresh snow. It's been falling all day, and tonight when I went out I found no remnants of my creations. I made a few more as I went, placing them in more obvious locations like on people's front steps and on the bus stop seat.

Today we had a visit from Jennifer Phelps from Burnet Art Gallery in Minneapolis. She suggested that the reason I am having difficulties resolving the big portrait of myself might be because there are a number of colours in the piece. All the other pieces I have done revolve around black plus another colour. This was something that neither Anne nor I had picked up. As a direct result of this conversation, and in an attempt to unify the piece, I set to work this afternoon and outlined all the gesso ridges across the entire painting with crimson. Now she is behind `a web of fine lines` that look like a broken window across her.

I will now cover her with layers of tinted polymer gloss and see how far into the background I can push her.

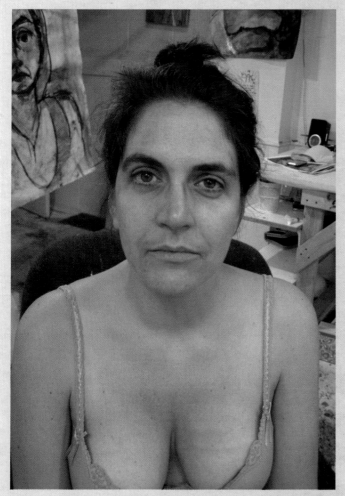

Anne: Sensible though it is to get a decent night's sleep, I want a good night in the studio and don't want to waste it sleeping. Not even kind of.

Last night I made beets for dinner and saved the liquid. I have used this on two pieces tonight and there is still some left. It's a lovely colour which gives way immediately to the airbrush pigments.

I also started several self-portraits from a new photograph. The printer was running out of ink and the photo came out a putrid green. This, together with the fact that I am in my bra, has been pivotal to the work. Unusually, according to Carole, I am not wearing my 'holocaust look'. I'm more like a samurai warrior with my hair piled into a bun atop my head. The seminudity of this photo means that I have access to the bone structure, and you can see my bosom. It gives a real rawness, a nakedness to the portraits. (America, just relax!)

39

Anne: Tonight at the crit we discussed the viability of each portrait currently in play. The beet portraits have a really interesting and luminous quality and a great colour to them. They are developing depth, and the crimson teamed with green is awesome.

I've been thinking about the scale of my portraits. There are three sizes, but mostly I am working at 30 × 44 inch. The scale is really important to the works, largely because the head size is larger than an actual human head; therefore the expression of **emotion is amplified** and is more penetrating. A smaller scale doesn't make the same impression and is perceived completely differently. Reflecting back on an earlier diary entry about full-frontal portraits, it occurs to me that it's not just the pose that contributes to the piece's openness and vulnerability, but the scale as well.

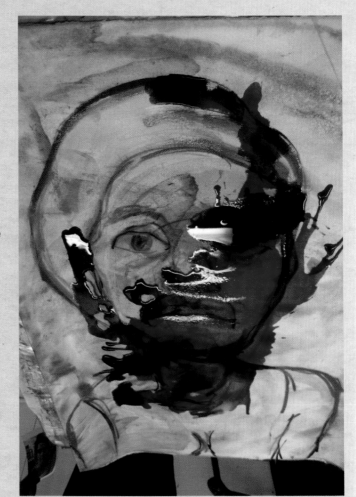

40

Carole: So enamoured is she with her beetroot-coloured portraits that Anne forgot to mention tonight is my last working night here, which is making me both *happy and sad.*

I feel happy because I know I have achieved a lot. I have moved forward both with understanding and using acrylic polymer medium as an artist's material. On a personal level, I have also developed my understanding of portrait-making; after living through the birth of the 'scary me' portrait, I have a much greater insight into the difference between painting my image for an audience, and visually portraying myself from a place of deep connection with that self.

I am also happy about going home to my family— busting to see Richard, the boys and the puppies.

I'm sad because it means the closure of that special month that Anne and I only get biennially, and then at considerable cost to our respective families and the other parts of our lives.

I am also sad to be leaving Anne. I couldn't ask for a better Dungeonmate. Spending eighteen hours a day below ground without air or daylight has once again concreted our friendship and mutual artistic respect.

I am not looking forward to the long flight home.

Anne: The work still lives and breathes in my studio. I continue to paint every day, trying to maintain the same energy I felt when Carole and I were together. Although working alone is different in so many ways, some things stay the same: the glooping continues every night, and the emotional content still thrives. Sometimes it is about trees and nature (it's spring!) instead of my face.

Of my pieces produced during the month with Carole, one is currently on view in a juried (that's 'curated', for our Australian readers) gallery event in New York City. Six have been accepted into *New American paintings* magazine. One will be on view in a collector's home during a tour with Friends of the Minneapolis Institute of Arts in June. Two of my woodcuts have been accepted for the *2nd Penang international print exhibition 2010* which will be on show at the Universiti Sains Malaysia in September and October. In November, a large group of the works will feature in my exhibition at Athenaeum Music & Arts Library in La Jolla, California. I'll also be talking about my work and process as part of their gallery tour program.

The early response to these new pieces has been very encouraging, and as a result I have fresh ideas and feel motivated to actively promote and exhibit the work. Basically, I'm on a roll!

Carole: Coming home is *always* bad for my art. The transition from one world to another is disruptive, to say the least. Even though I bring home pieces that are in progress, I am unable to pick up where I left off. It takes me a long time to re-establish myself in the physical space of my studio; to get used to working above ground in natural light, to reorientate myself to my paint and my range of colours again, and most of all to work without my Dungeonmate.

So, on my return, I began several new pieces in another series I am working on: portraits of rocks. Although I am without access to gloop here in Australia, I can feel the process of glooping influencing these works; I am working in broad areas with tones of colour in layers, using oils thinned down in solvent and medium, and spreading each layer with a palette knife.

I have continued working on some of the portraits I began in America. Oddly, some of the ones that I'd felt were finished when I left Anne's, I saw with new eyes once I got home, and realised there was more to be done. I have added a large shadow onto the red background of one of my series of 'side mouths'. I am happy with her now. Another side mouth—this one with yellow hands—has also been reworked: more drips added and some resolution to the eyes as well. She's also looking pretty damn fine!

While I am glad to be home, I also miss working with Anne. Spending those intensive weeks together provides many things for me. It allows me the pure pleasure of focusing uninterrupted on a large body of work, encourages me to take creative risks, and gives me the opportunity to gain mastery in new Dungeon matters (like dealing with gloop, or drawing a shoulder). Above all, it cements a friendship that is worth its weight in gold.

A day in the life ... of a Dungeonmate

Our day begins in the early hours of the morning when we are to be found in the studio. Typically after midnight our artmaking is quiet and concentrated—it's a time when we can both work without interruption.

The glooping process—which involves covering all the work with acrylic emulsion to blend and tone it—begins after 2 am, and usually takes somewhere between an hour and an hour and a half. Every piece gets glooped for sealing and fixing purposes as well.

Technically bedtime is 3 am. Curfew is 3.30 am, but as is common with curfews it has been broken. The record for bodies in bed is 4.10 am and is held by Anne, who was then woken at 5.20 am by her seven-year-old son, dressed and ready for school!

Anne does the preparations for school, and sometimes the school run, from 6.30 to 8.30 am, then on a good day returns to bed. Carole comes down at about 10 am and prepares breakfast while Anne sits comatose at the table moaning over her coffee. Once adequately caffeinated we descend below ground for another day.

Our morning artmaking may include looking over the gloopers from the night before, cleaning and reorganising our space and thinking through the goals of the day out loud. There is a morning discussion: an intense, specific, often critical, and always observant commentary about each work in the making loop.

Lunch rarely happens, but sometimes various small bowls of leftovers make their way downstairs, consumed hurriedly while the art dries.

At 2.40 pm Anne usually does the school run to collect all three children, except on the days when each child goes in a different direction for after-school activities. Sometimes, if we are lucky, a babysitter does the drive and dump, and the basketball game delivery and collection duties.

In the afternoons we are often accompanied by one or two of the children as they do their own artmaking and talk about ours. This is the time when they like to give us awards—not all of them glowing. The favourite from Anne's youngest son is the Hot Shit Award, and, to his credit, he follows the, 'You can say that only in the Dungeon' rule scrupulously. Anne's daughter operates outside the award system, making her own poignant, and sometimes painful, observations.

Anne prepares dinner between the collections and distributions of children and homework supervision. Meanwhile, Carole leaves the house for a walk, usually down to the Mississippi River. After dinner Carole does the kitchen and laundry duties, while Anne gets the children organised for bed.

Dungeon time starts as soon as you can get there.

The evening session always begins with champagne, and we continue the work begun during the day. By midnight Carole is getting hungry. We take it in turns to prepare the snack.

Much care and thought goes into this selection and it's often the best meal of the day. Cheese is always consumed: Manchego, Parmigiano-Reggiano, fetta, fresh mozzarella, a beautiful hard white goat's cheese, and the favourite—a to-die-for Brillat-Savarin Affine, which is taken from the fridge at lunchtime so it can soften adequately for our midnight repast. Anne's homemade bread is timed to come out of the oven at midnight precisely. Then there are nuts, fresh dates, olives, Triscuits, Duluth locally-made smoked salmon, corn chips and homemade salsa.

At midnight, along with our snack, we have the evening critique—this is when the going gets tough and the hard questions are dealt with. Discussions about art, its meaning and processes are all recurring topics.

With Bill in bed we can safely turn off the furnace fans, and the Dungeon descends into quietness. At this moment the Dungeon is at its most blissful.

Our favourites

Once again, we've compiled the definitive list of things that had the power to make our Dungeon days perfect!

Favourite snack: Brillat-Savarin Affine cheese and Duluth locally-made smoked salmon.

Most loved to drink: Cristalino Brut Cava (Spain, Metodo Tradicional).

Loved almost enough to drink: GOLDEN Acrylic Polymer Gloss Medium.

Favourite friend: GOLDEN Technical Support (+1 607 847 6154), where a real human bean will answer your questions.

Favourite absent friend: Harold Adams.

Favourite tools: empty Kikkoman Soy Sauce bottles, two-quart size, with snap-shut lid and pouring lip (for dispensing gloop); Liquitex super-sized palette knife (for spreading gloop); isopropyl alcohol in a spray bottle (for fixing pastel and making us drunk with the vapour); Rives BFK paper.

Most played music: Nick Cave's *The boatman's call*. (However, excessive repetition has jaded Anne's sensibility to this music: in other words, she never wants to hear it again!)

Favourite art material: GOLDEN Fluid Acrylics, for their fluidity and steadfast pigments.

Most troublesome body parts (to paint): eyebrows, necks and, of course, shoulders.

Grossest Dungeon behaviour: Carole not washing her hair for twelve days, much to the horror of Anne's nine-year-old daughter!

Plates

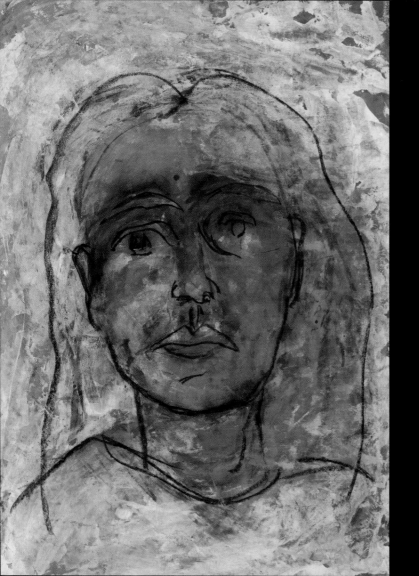

ANNE LABOVITZ, *MUD GIRL*,
MIXED MEDIA ON RIVES BFK,
30 x 44 INCHES

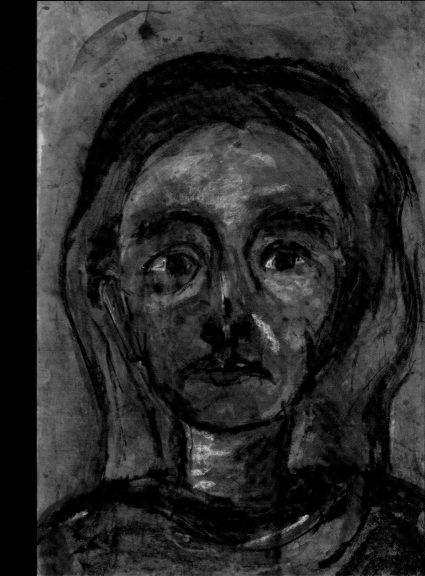

ANNE LABOVITZ, *SELF-PORTRAIT NO. 12*,
MIXED MEDIA ON RIVES BFK,
30 x 44 INCHES

ANNE LABOVITZ, *SELF-PORTRAIT NO. 3,*
MIXED MEDIA ON RIVES BFK,
30 x 44 INCHES

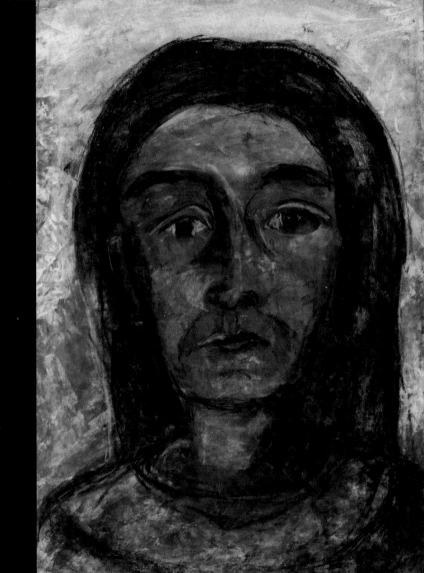

ANNE LABOVITZ, *SELF-PORTRAIT NO. 2*,
MIXED MEDIA ON RIVES BFK,
30 x 44 INCHES

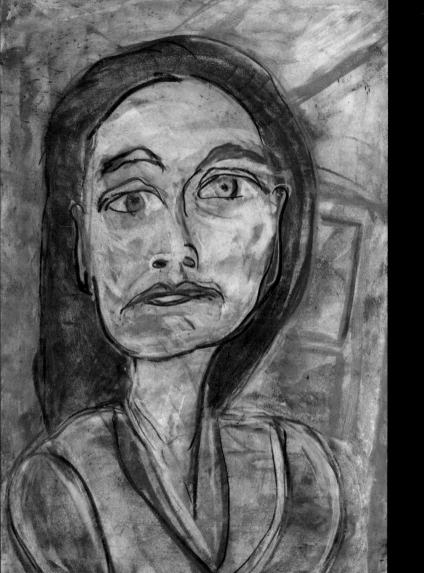

ANNE LABOVITZ, *SELF-PORTRAIT NO. 20*
MIXED MEDIA ON RIVES BFK
30 x 44 INCHES

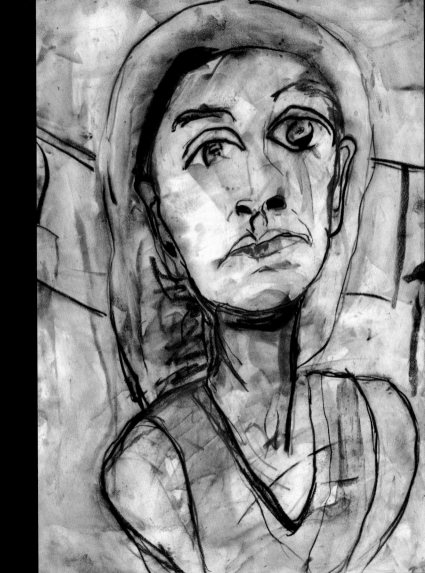

ANNE LABOVITZ, *SELF AT 45 (BIRTHDAY PORTRAIT)*,
MIXED MEDIA ON RIVES BFK,
30 x 44 INCHES

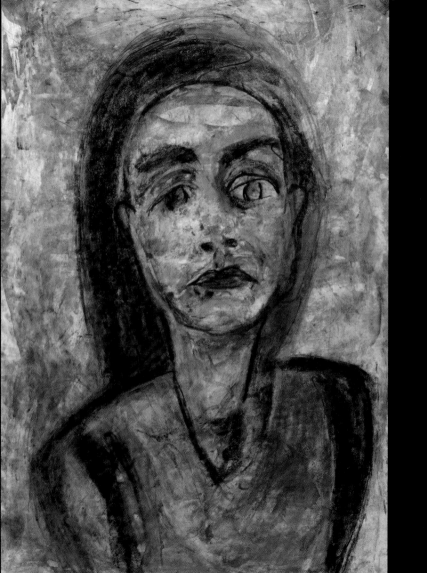

ANNE LABOVITZ, *SELF-PORTRAIT NO. 8*

MIXED MEDIA ON RIVES BFK

30 x 44 INCHES

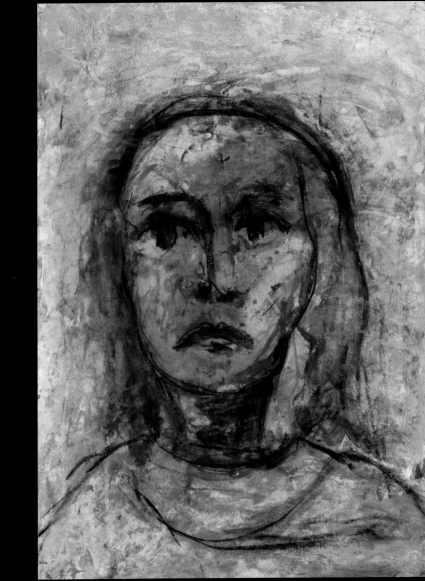

Anne Labovitz, *Wind girl*,
mixed media on Rives BFK,
30 x 44 inches

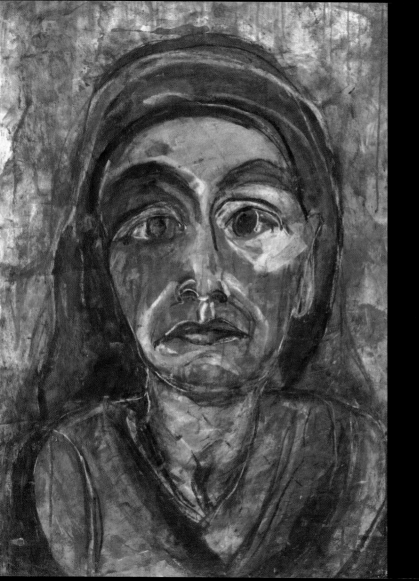

ANNE LABOVITZ, *SELF-PORTRAIT NO. 11*,
MIXED MEDIA ON RIVES BFK,
30 x 44 INCHES

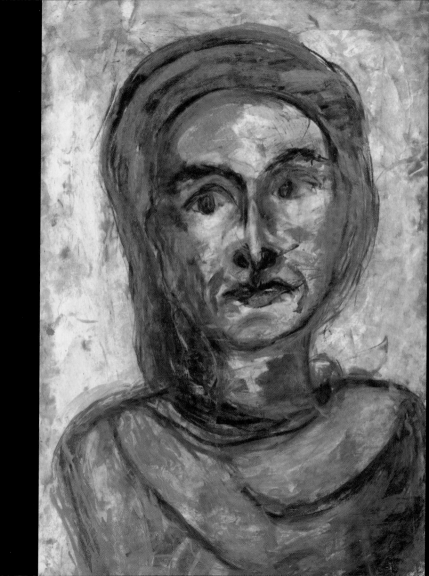

ANNE LABOVITZ, *SELF-PORTRAIT NO. 4,*
MIXED MEDIA ON RIVES BFK,
30 x 44 INCHES

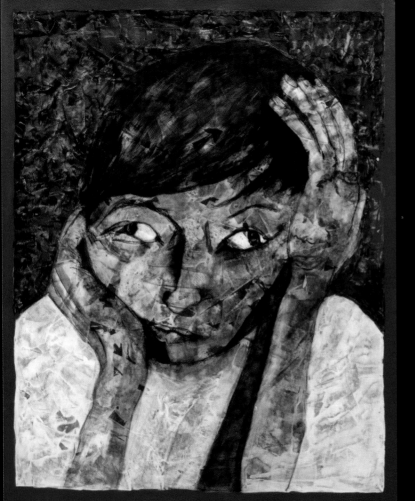

CAROLE BEST, *LOOKING FOR JOY HESTER*
(SELF-PORTRAIT),
MIXED MEDIA ON LENOX PAPER,
100 x 120 CENTIMETRES

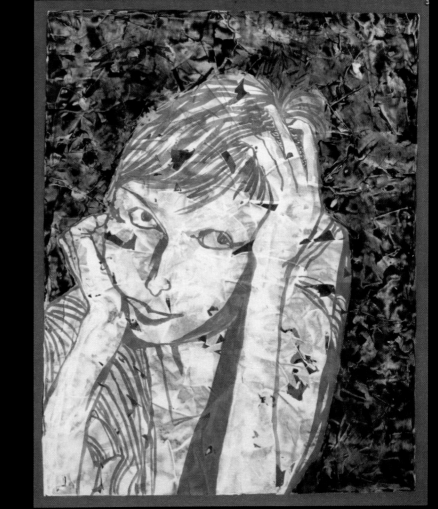

CAROLE BEST, *INK ME (SELF-PORTRAIT)*,
MIXED MEDIA ON LENOX PAPER,
100 x 120 CENTIMETRES

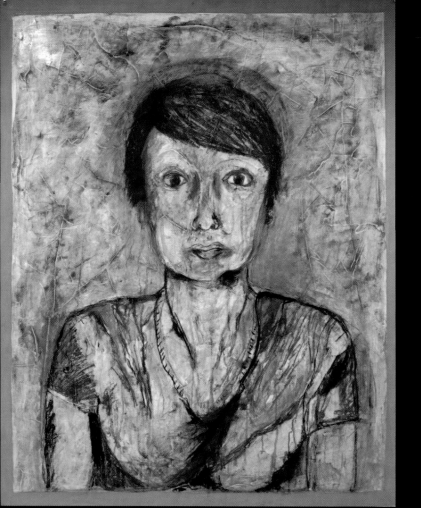

CAROLE BEST, *SELF-PORTRAIT*,
MIXED MEDIA ON LENOX PAPER,
100 x 120 CENTIMETRES

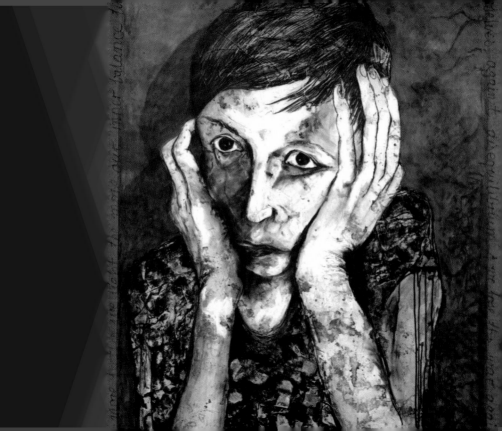

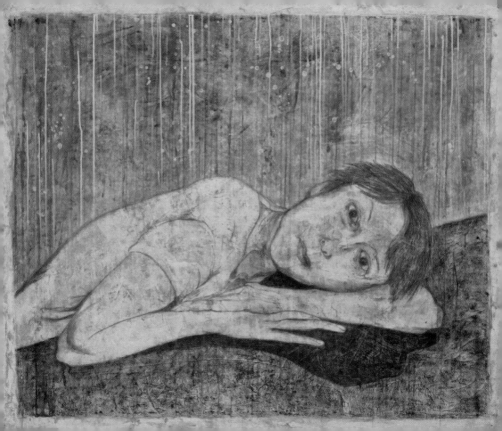

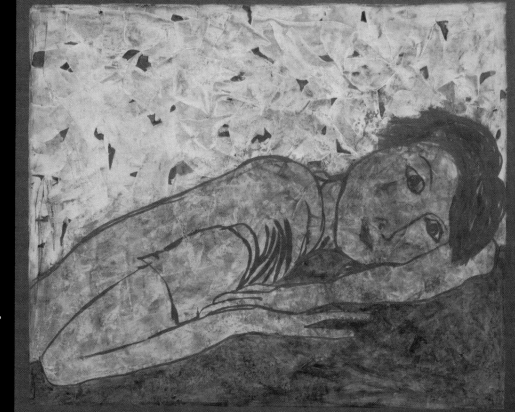

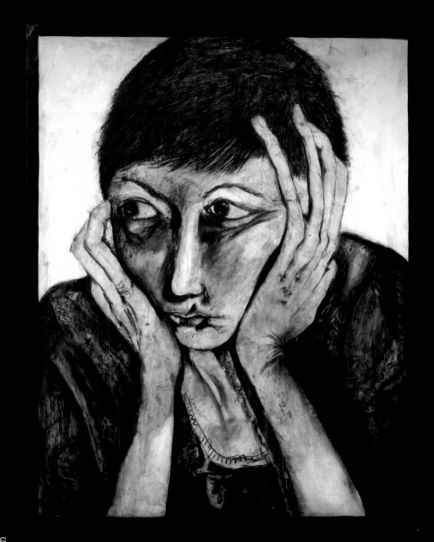

CAROLE BEST, *I PAINT, THEREFORE I AM*
(SELF-PORTRAIT),
MIXED MEDIA ON LENOX PAPER,
100 x 120 CENTIMETRES

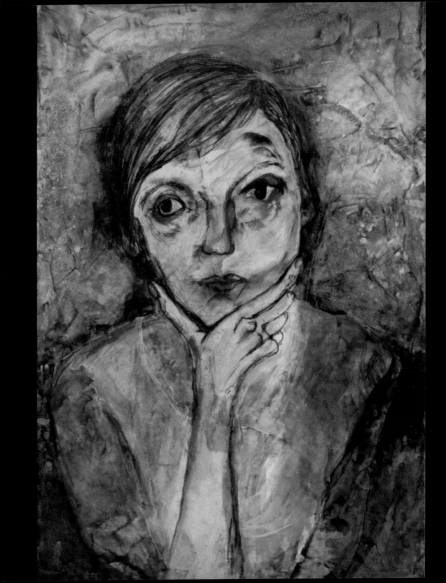

CAROLE BEST, *SELF-PORTRAIT*,
MIXED MEDIA ON RIVES BFK,
76 x 112 CENTIMETRES

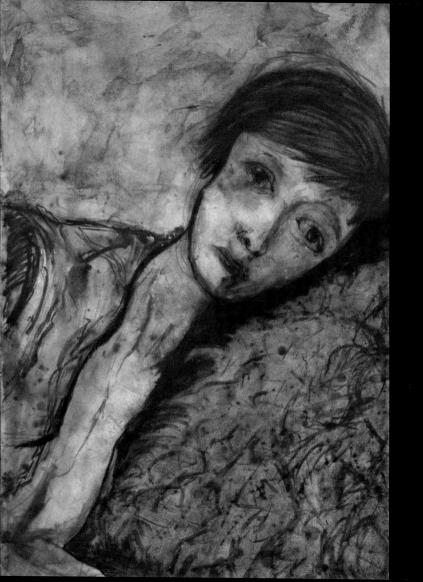

CAROLE BEST, *SELF-PORTRAIT*,
MIXED MEDIA ON RIVES BFK,
76 x 112 CENTIMETRES

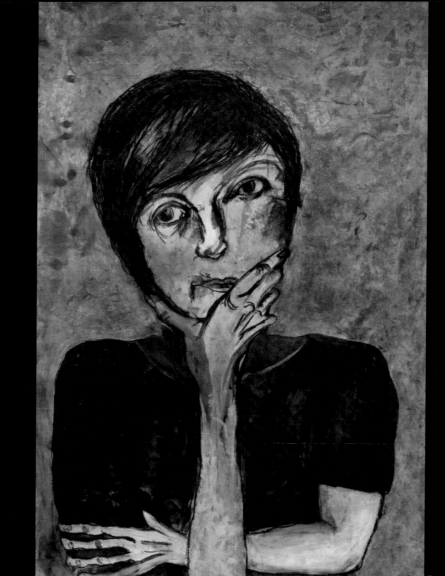

CAROLE BEST, *SELF-PORTRAIT*,
MIXED MEDIA ON RIVES BFK,
76 x 112 CENTIMETRES

Acknowledgments

As always, our heartfelt thanks go to our families who through their generous demeanours and goodwill support our time together.

Special thanks goes to Bill Gamble who (not for the first time and hopefully not for the last time) had the grace and kindness to allow Dungeon business to take over his wife and home for four whole weeks!

Mention should also be made of Anne's children who not only delight, inspire, and entertain us, they keep us grounded in the real world.

During our Dungeon time we often thought of and talked about Harold Adams, who over the years has reminded us that the best way forward is to *just keep going*.

And lastly, a big thank you to our editor, Penny O'Hara, who came up with many brilliant suggestions for this book and kept us perfectly on time and within budget!